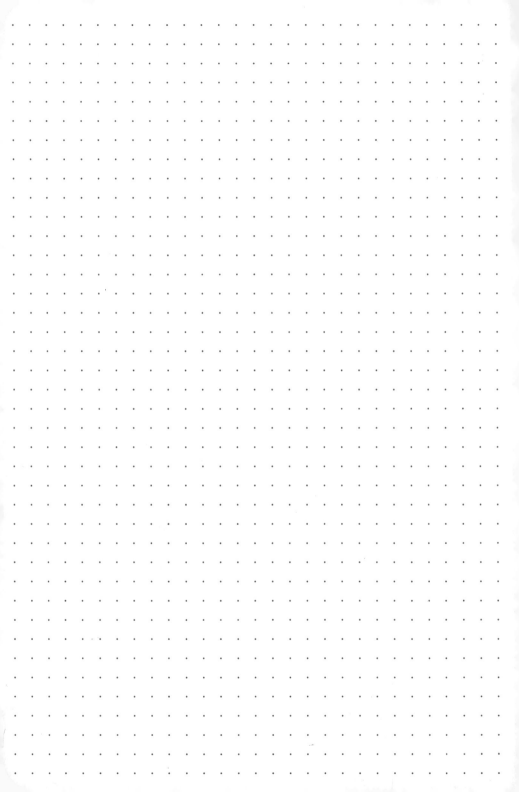

Work

Dr. Stephonson Calender Jan-Feb. Classic/WADOC
M
6

Monday - WADOC interview 6, 7, 8, 10:00, 11, 12, 1
Tuesday -
Wednesday

Monday - 6, 7, 8, 10, 11, 12, 1
Tuesday - 6, 7, 8, 9, 11, 12, 1

Monday - 6, 7, 8, 10, 11, 12, 1
Tuesday - 6, 7, 8, 9, 11, 12, 1 } DR/stephenson
Wednesday - 6, 7, 8, 9, 11, 12, 1
Thursday - 6 7 8 9 11 12
Friday - 6, 7, 8, 9, 10, 11, 12, 1

Months by Nola

- January — 1:00pm — hail — orange
- February — 5:00 pm — Sun — Blue
- March — 2:00 pm — light rain — green
- April — 6:00 am — Overcast — ~~NTA~~ Red
- May — 7:00 — Rain hard —
- June — 11:00am — Sonshine — ~~Sunny~~ — Stripes RYB
- July — 12:00 pm — Hot — Yellow
- August — 9:00pm — Overcast/Rain — grey
- September — 3:30 pm — Green — varries
- October — 6:00pm — Black — Dark/night
- November — 6:00pm — Orange — Rain
- December — 12:00pm — Snow — Midnight blue

14 years old ♥

figure skating ♥ Jan 6 2023 ♥

Today I had my first figure skating lesson, and I am in love. Even though their are a bunch of like 6 year olds in my class I love it. My teachers are the absolute sweetest and so helpfull when I have a question. Im assuming its nice for them to have a break from a lot of younger kids. The time absolutely flew and when I saw some girls doing spins I was in love. There is also this girl who seems so nice in a lvl 4 class and someday I hope we are freinds♥ Seeing my teacher skate across the ice so effortless was geourgeous. I know I ~~are goi~~ have just found something I love and will love for a while. I cant wait to be able to buy my own skates, I need the rest of me to grow and my feet stay the same ♥ Also I think Roller skating came in clutch.

shopping

- ◯ leg warmers
- ◯ flared leggings
- ◯ warm gloves

Skating Pass ♥

January 7th 2024 Night

6:00 → get stuff for clean

6:30 → Get ready for workout

6:45 → Workout

7:25 → Shower

7:45 → Pack bag

8:00 → dinner

8:30 → Skincare

8:45 → Read

9:30 → Tv/Movie

10:30 → Sleep 🌙 💗

January 9th 2023

~~Homework~~ 6:20 → homework

- ~~Pilates~~ 6:40 → Pilates

- ~~Shower~~ 7:05 → Shower

 7:30 → Read

 8:00 → Skincare

 8:15 → Pack bag / mock trial

 8:30 → Movie (Spiderman)
 ↳ Schedule morning
 9:30 → audiobook + Sleep

January 10th 2023

5:~~95~~ → wake up / get out of bed
5:50 → 🌸 Yoga stretch
6:05 → ~~Mask~~ skincare / makeup
6:25 → ~~Matcha~~ Change
6:30 → Matcha
6:40 → Breakfast ♡ ♡ ♡
7:10 → Pack bag

Homework 🌸

- Delta math
- Desmos
-

January 13 2023

8:30 → wake up ~~Page~~
8:45 → Skincare
9:00 → food
9:30 → Laundry / clean
10:15 → School / work

11:15 → Read
11:45 → Relax

?:?? → skates come

5:00 → Math

6:00 → clean laundry

Group 1 →

Group 1

← queen

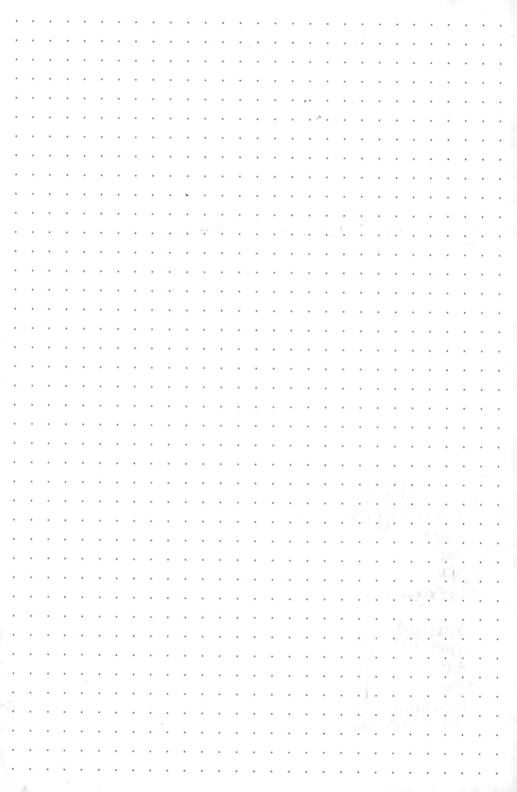

February 16 2024

- O Arabic group project ➜ tmrw
 - O Finish musician research
 - – translate + print group discussion

- Ø Arabic assignments
 - ● level up log O write down week 6 words
 - Ø Competency check

- O No red ink / readin 2 chapters
 - O 9.1
 - O 9.2
 - O 9.3

- O Delta math 50%

- Ø Big 9 ➜ do 25%

February 18 2024

- O Clean room
 - ● wipe surfaces
 - O water plants
 - O put away clothes
 - O laundry
 - ● make bed
 - O vaccum
 - ● Reorganize desk

- O Skating
 - O one foot glides
 - O two foot turns
 - O Backwards glides
 - O Backwards snostop
 - O forward strach

February 22 2023

- ⊙ Arabic
 - ⊙ discussion
 - ⊙ lvl up log
 - ⊙ finish research
 - ⊗ Translateion
- ⊗ Delta math → 100%

- ⊙ finish reading → 18 / fill out reading log
- ⊙ call arabic parter 8:45 pm

February 23 2024

- ⊙ Arabic
 - ⊙ lvl up log
 - ⊙ competency quiz
 - ⊙ discussion

⊙ english

- ⊙ Finish reading → lvl up log
- ⊙ NRI

- ⊙ Physics
 - ⊙ Exel graph
 - ⊙ Anylize questions

Next two weeks

- O go skating twice
 - -1 in london
 - -1 in txs

- O Arabic March 11 → 15

- O fill out EYC signature

- O Fill out class appeal

- O Pack for break

- O Have a safe flight ♥

- O Delta

- O Fly home!!! ♥ March 17

- O Morning practice march 18 ♥♥♥

Delta math

① $\frac{90}{x} = \frac{185}{109.2}$ › $\frac{90 \cdot 185}{x} = \frac{185}{109.2}$

$x = 109.2$

~~~~~~~~~~~~~~~~~~~~~~

Jans. Big.9

Goverment
- kind of ruler
- kind of goverment
- any notable rulers
- Timeline of your Civiliz

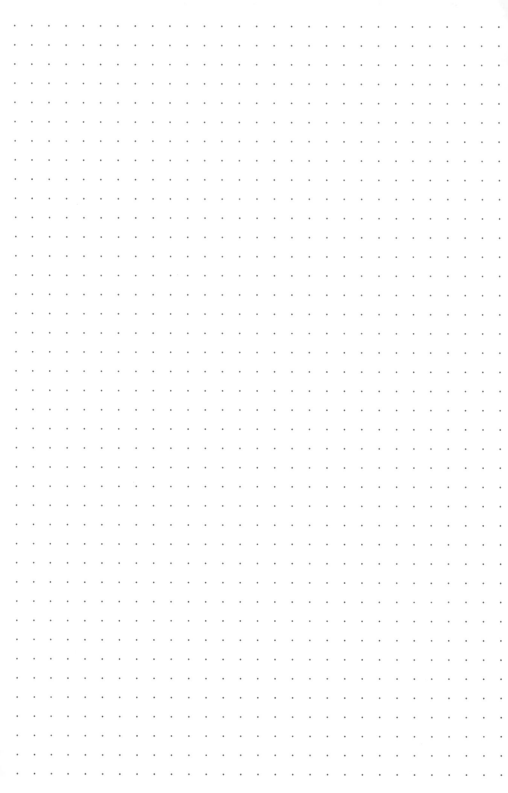